WHAT HAPPENED
TO ART CRITICISM ?

WHAT HAPPENED TO ART CRITICISM ?

James Elkins

PRICKLY PARADIGM PRESS
CHICAGO

Prickly Paradigm Press, LLC
5629 South University Avenue
Chicago, Il 60637

www.prickly-paradigm.com

ISBN: 0-9728196-3-0
LCCN: 2003111002

Fourth printing, March 2007

Printed in the United States of America on acid-free
paper.

Table of Contents

1

Art Criticism: Writing Without Readers

Art criticism is in worldwide crisis. Its voice has become very weak, and it is dissolving into the background clutter of ephemeral cultural criticism. But its decay is not the ordinary last faint push of a practice that has run its course, because at the very same time, art criticism is also healthier than ever. Its business is booming: it attracts an enormous number of writers, and often benefits from high-quality color printing and worldwide distribution. In that sense art criticism is flourishing, but invisibly, out of sight of contemporary intellectual debates. So it's dying, but it's everywhere. It's ignored, and yet it has the market behind it.

There is no way to measure the sheer quantity of contemporary writing on visual art. Art galleries almost always try to produce at least a card for each exhibition, and if they can print a four-page brochure (typically made

from one sheet of heavy card stock, folded down the middle) it will normally include a brief essay on the artist. Anything more expensive will certainly include an essay, sometimes several. Galleries also keep spiral-bound files on hand with clippings and photocopies from local newspapers and glossy art magazines, and gallery owners will gladly copy those pages for anyone who asks. An afternoon walk in the gallery district of a city in Europe, North or South America, or southeast Asia can quickly yield a bulky armful of exhibition brochures, each one beautifully printed, and each opening with at least a hundred-word essay. There is also a large and increasing number of glossy art magazines, despite the fact that the market is very risky from an entrepreneur's point of view. Large magazine displays in booksellers such as Eason's and Borders carry dozens of art magazines, and glossy art magazines can also be found in newsstands near museums and in college bookstores. No one knows how many glossy art magazines there are because most are considered ephemeral by libraries and art databases, and therefore not collected or indexed. There are so many that no one I know even attempts to keep track. As a rule, academic art historians do not read any of them. At a rough guess, I would say there are perhaps two hundred nationally and internationally distributed art magazines in Europe and the United States, and on the order of five hundred or a thousand smaller magazines, fliers, and journals. No one knows how many exhibition brochures are produced each year, mainly because no one knows how many galleries there are in the world. Large cities such as New York, Paris, and Berlin have annual gallery guides, but they are not complete and there is no definitive listing.

As far as I know no library in the world collects what galleries produce, with exceptions at the high end of the market. Daily newspapers are collected by local and national libraries, but newspaper art criticism is not a subject term in any database I know, so art criticism published in newspapers quickly becomes difficult to access.

In a sense, then, art criticism is very healthy indeed. So healthy that it is outstripping its readers—there is more of it around than anyone can read. Even in mid-size cities, art historians can't read everything that appears in newspapers or is printed by museums or galleries. Yet at the same time art criticism is very nearly dead, if health is measured by the number of people who take it seriously, or by its interaction with neighboring kinds of writing such as art history, art education, or aesthetics. Art criticism is massively produced, and massively ignored.

Scholars in my own field of art history tend to notice only the kinds of criticism that are heavily histori-cally informed and come out of academic settings: princi-pally writing on contemporary art that is published in art historical journals and by university presses. Art historians who specialize in modern and contemporary art also read *Artforum*, *ArtNews*, *Art in America*, and some other jour-nals—the number and names are variable—but they tend not to cite essays from those sources. (A few historians write for those journals, but even then it's rare to find them citing art magazines.) Among the peripheral journals is Donald Kuspit's *Art Criticism*, which has only a small circulation even though it should in principle be of interest to any art critic. The others are a blur—*Art Papers*, *Parkett*, *Modern Painters*, *Tema Celeste*, *Frieze*, *Art*

Monthly, Art Issues, Flash Art, Documents sur l'art—and the list melts away into the glossy magazines that are just not read much inside the academy—*Revue de l'art, Univers des arts, Glass, American Artist, Southwest Art...* Art historians generally do not get very far along that list. The same can be said of art historians' awareness of newspaper art criticism: it's there as a guide, but never as a source to be cited unless the historian's subject is the history of an artist's reception in the popular press. If an anthropologist from Mars were to study the contemporary art scene by reading books instead of frequenting galleries, it might well seem that catalog essays and newspaper art criticism do not even exist.

Do art criticism and catalog essays function, then, primarily to get people into galleries and to induce them to buy? Probably, but in the case of catalog essays the economic effect does not seem to depend on the writing actually being read—often it is enough to have a well-produced brochure or catalogue on hand to convince a customer to buy. It is not entirely clear that criticism affects the art market except in prominent cases, when the buzz surrounding an artist's show can certainly drive up attendance and prices. In my experience, even art critics who work at prominent newspapers receive only a modicum of letters except in unusual cases. The same phenomenon occurs on the internet, in regard to e-zines and groups: weeks and months can pass with no sign that the texts are being read, and those deserts are punctuated by flurries of emails on controversial issues.

So in brief, this is the situation of art criticism: it is practiced more widely than ever before, and almost completely ignored. Its readership is unknown, unmea-

sured, and disturbingly ephemeral. If I pick up a brochure in a gallery, I may glance at the essay long enough to see some keyword—perhaps the work is said to be "important," "serious," or "Lacanian"—and that may be the end of my interest. If I have a few minutes before my train, I may pause at the newsstand and leaf through a glossy art magazine. If I am facing a long plane flight, I may buy a couple of magazines, intending to read them and leave them on the plane. When I am visiting an unfamiliar city, I read the art criticism in the local newspaper. But it is unlikely (unless I am doing research for a project like this one) that I will study any of those texts with care or interest: I won't mark the passages I agree with or dispute, and I will not save them for further reference. There just isn't enough meat in them to make a meal: some are fluffy, others conventional, or clotted with polysyllabic praise, or confused, or just very, very familiar. Art criticism is diaphanous: it's like a veil, floating in the breeze of cultural conversations and never quite settling anywhere. The combination of vigorous health and terminal illness, of ubiquity and invisibility, is growing increasingly strident with each generation. The number of galleries at the end of the twentieth century was many times what it was at the beginning, and the same can be said of the production of glossy art magazines and exhibition catalogues.

Newspaper art criticism is harder to measure, although it seems likely there is actually less of it, relative to the population size, than there was a hundred years ago. According to Neil McWilliam, in 1824 Paris had twenty daily newspapers that ran columns by art critics, and another twenty revues and pamphlets that also covered the Salon. None of those writers were employed as art critics,

but some were virtually full-time just as they are now. Today, even counting the internet, there is nowhere near the same number of practicing critics. So it is possible that newspaper art criticism has gone into a steep decline, and that would be in line with the absence of art criticism from contemporary cultural programming on television and in radio. Some of the early nineteenth-century art critics were taken seriously by contemporaneous philosophers and writers, and others—the founders of western art criticism—were themselves important poets and philosophers. The eighteenth-century philosopher Denis Diderot is effectively the foundation of art criticism, and he was also a polymath and one of the century's most important philosophers. By comparison Clement Greenberg, arguably modernism's most prominent art critic, bungled his philosophy because he was uninterested in getting Kant any more right than he needed to make his points. A good case can be made that Charles Baudelaire enabled mid-nineteenth century French art criticism in a way that no other writer did, and he was of course also an indispensable poet for much of that century and the twentieth. Greenberg wrote extremely well, with a ferocious clarity, but in the hackneyed phrase he was no Baudelaire.

These comparisons are perhaps not as unjust as they may seem, because they are symptomatic of the slow slipping of art criticism off the face of the cultural world. Who, after all, are the important contemporary art critics? It is not difficult to name critics who have prominent venues: Roberta Smith and Michael Kimmelman at *The New York Times*; Peter Schjeldahl at the *New Yorker*. But among those who aren't fortunate enough to work for publications with million-plus circulation, who counts as a

truly important voice in current criticism? My own list of most-interesting authors includes Joseph Masheck, Thomas McEvilley, Richard Shiff, Kermit Champa, Rosalind Krauss, and Douglas Crimp, but I doubt they are a canon in anyone else's eyes, and the cloud of names behind them threatens to become infinite: Dave Hickey, Eric Troncy, Peter Plagens, Susan Suleiman, Francesco Bonami, Kim Levin, Helen Molesworth, Donald Kuspit, Buzz Spector, Mira Schor, Hans-Ulrich Obrist, Miwon Kwon, Germano Celant, Giorgio Verzotti—there are hundreds more. The International Association of Critics of Art (called AICA after the French version of their name) has over four thousand members and branches, so they claim, in seventy countries.

Early twenty-first century art critics may or may not be university trained: in a way it does not matter, because virtually none are trained as art critics. Departments of art history almost never offer courses in art criticism, except as an historical subject in courses such as "The History of Art Criticism from Baudelaire to Symbolism." Art criticism is not considered as part of the brief of art history: it is not an historical discipline, but something akin to creative writing. Contemporary art critics come from many different backgrounds, but they share this one crucial absence: they were not trained as art critics in the way that people are trained as art historians, philosophers, curators, film historians, or literary theorists. There is a limit, I think, to how little this might matter. Just because a field has no academic platform does not mean that it is less rigorous, or less attached to the values and interests of adjacent fields that do have the imprimatur of formal training. But the lack of an academic practice of art

criticism—with a few interesting exceptions, such as the program at Stony Brook—means that art criticism is unmoored. Its freedom is exhilarating, occasionally, but for a steady reader it is stultifying. Among the various reasons for art criticism's vertiginous freedom, its swoops and feints in and out of a dozen disciplines, is its lack of a disciplinary home. I do not mean that criticism would be better off if it were constrained by a conservative or fixed pedagogy: but if it were disciplinary in any sense, it would have a center of some kind against which to push. At the moment art critics feel very little resistance. A critic who writes exhibition brochures and catalogues will be constrained a little by the expectation that the piece will not be unfavorable, and a critic who writes for a large-circulation newspaper will be constrained because the public is unused to new art, or accustomed to moderate opinions. But those and other sources of constraint are minor in comparison with the lack of restraint that is granted to art critics by the absence of an academic home. An academic discipline, as fractious and contradictory as it may be, puts two kinds of pressure on a practitioner: it compels an awareness of colleagues, and it instills a sense of the history of previous efforts. Both are absent, with spectacular and fantastical effect, from current art criticism.

This is the picture of art criticism as I would paint it: it is produced by thousands of people worldwide, but it has no common ground. Art criticism involves a fair amount of money by academic standards, because even modest exhibition brochures are printed in large numbers, on coated stock, with high-quality plates that are rare in academic publishing. Even so, art critics very rarely earn

their living from writing criticism. More than half of those with jobs at the top American newspapers earn less than $25,000 per year, but successful freelance critics may write twenty or thirty essays per year, at a base fee of $1,000 per essay or $1 to $2 per word, or $35 to $50 for a brief newspaper review. (My own experience is probably about average; I have charged between $500 and $4,000 for essays between one and twenty pages long.) Critics who are actively writing will also be asked to lecture at art schools and travel to exhibitions, with all expenses paid and fees between $1,000 and $4,000. Articles in glossy art magazines pay between $300 and $3,000, and those essays can be used both to augment the critic's income and generate further invitations. By comparison an academic art historian or philosopher may easily spend a long and productive career without ever being paid for any publication. Criticism is ubiquitous, then, and sometimes even profitable: but it pays for its apparent popularity by having ghosts for readers. Critics seldom know who reads their work beyond the gallerists who commission it and the artists about whom they write: and often that reading public is ghostly precisely because it does not exist. A ghostly profession, catering for ghosts, but in a grand style.

*

As recently as the first half of the twentieth century, art criticism was very different. Art critics were more likely to be concerned with the history of art, including the history of their own practice. It was more common then for critics to think on large scales, comparing their judgments on different occasions, or considering the differences between

their positions and those of other critics. Bloomsbury critics like Roger Fry and Clive Bell felt they could stand back and assess large regions of history. Bell's manifesto *Art* demotes everything between the twelfth century and Cézanne: he calls the Renaissance "that strange, new disease," and says that Rembrandt was a genius, but also "a typical ruin of his age." Judgment itself was presented more ambitiously in Bell's generation, as a matter of broader comparisons. Contemporary critics tend not to think outside the box of the exhibition or particular work at hand, or rather they write as if they weren't thinking outside the box. At glossy art magazines, that's sometimes the implicit charge: do not pontificate or wander: stick to the theme.

Early and mid-twentieth century American art critics were also fiercely opinionated and even polemical. At the turn of the century Royal Cortissoz, the stubbornly conservative critic for the *New York Tribune*, fought every-thing modern except Matisse, and a generation later John Canaday, the backward-looking critic for the *New York Times*, battled Abstract Expressionism with a sarcastic violence that seems outlandish today. Cortissoz, known as a "square shooter," found most European art of the first two decades of the century "crude, crotchety, tasteless," and "arrogant." In a column written in 1960, Canaday critiqued a "dried and caked puddle of blue poster paint" that he found on a wall, pretending it was painting called *Blue Element* by a painter named Ninguno Denada. He wrote a full-length review of the spill, declaring it "deeply impres-sive, a profound interpretation of our century of crisis," comparing Denada to the real-life painters Modest Cuixart, Antoni Tàpies, and Joan Miró, and then refusing to distin-

guish between his "satire" and the "brainwashing that goes on in universities and museums." It is hard to imagine a *New York Times* critic these days being that sarcastic. (And the comparisons to Cuixart, Tàpies, and Miró are entirely unfair. Even Cuixart's most uncontrolled paintings have carefully drawn elements superimposed. The real target, of course, was Pollock.)

It is not necessarily the case that critics have become less opinionated: there are many reasons for the changes I am describing, and I will be more specific later on. But I do mean that critics have become less ambitious—if by ambition is meant the desire to try to see the landscape of some art practice and not just the one thing in apparent isolation. There are few living art critics who have gone on the record with what they think of the twentieth century's major movements. Local judgments are preferred to wider ones, and recently judgments themselves have even come to seem inappropriate. In their place critics proffer informal opinions or transitory thoughts, and they shy from strong commitments. In the last three or four decades, critics have begun to avoid judgments altogether, preferring to describe or evoke the art rather than say what they think of it. In 2002, a survey conducted by the Columbia University National Arts Journalism Program found that judging art is the least popular goal among American art critics, and simply describing art is the most popular: it is an amazing reversal, as astonishing as if physicists had declared they would no longer try to understand the universe, but just appreciate it.

These differences, which I am going to try to flesh out, are enormous. During the same decades that art criticism proliferated around the world, it also receded from the

firing lines of cultural critique into the safer and more protected domains of localized description and careful evocation. I do not at all mean that criticism's intellectual purview has shrunk to fit the pluralism, jargon, and epistemological evasiveness that are so often associated with the academic left. I wouldn't argue that we need to regain the hairy-chested health of the impetuous critics of high modernism. It is true that the contemporary critics who are most ambitious in the sense I am using that word are also arch-conservatives, but I do not consider conservatism a promising or even relevant ideological direction for criticism. Writers like Hilton Kramer are deeply detached from what is most interesting in the art world, and it is in part their ambition that prevents them from being able to engage current questions in a promising manner. Yet I want to continue using the word ambition because it strikes me as a fascinating mystery that art criticism has turned so abruptly from the engaged, passionate, historically informed practice it was before the later twentieth century, into the huge, massively funded but invisible and voiceless practice it has effectively become.

I have just two questions in mind. First: does it make sense to talk about art criticism as a single practice, or is it a number of different activities with different goals? And second: does it make sense to try to reform criticism? That second question is prompted by some recent writing on the state of art criticism which has called for more rigor, clearer argument, and greater historical awareness. I am not sure that the situation is that easy to fix, or that the proposed measures are the right ones. In particular, it seems to me that calls for reform are often disguised desires to return to some idealized past. But more on that at the end.

2

How Unified is Art Criticism?

If I were to draw a picture of current art criticism I'd make it a hydra, fitted with the traditional seven heads. The first head stands for the catalog essay, the kind commissioned for commercial galleries. (It has been said that catalog essays are not art criticism, because they are expected to be laudatory. But that begs the question: if they aren't art criticism, what are they?) The second head is the academic treatise, which exhibits a range of obscure philosophic and cultural references, from Bakhtin to Buber and Benjamin to Bourdieu. It is the common target of conservative attacks. Third is cultural criticism, in which fine art and popular images have blended, making art criticism just one flavor in a rich stew. Fourth is the conservative harangue, in which the author declaims about how art ought to be. Fifth is the philosopher's essay, where the author demonstrates the art's allegiance to or deviation

from selected philosophic concepts. Sixth is descriptive art criticism, the most popular according to the Columbia University survey: its aim is to be enthusiastic but not judgmental, and to bring readers along, in imagination, to artworks that they may not visit. And seventh is poetic art criticism, in which the writing itself is what counts. This is the third-most popular goal of art criticism according to the Columbia University survey, but I suspect it is also one of the most widely-shared goals across the board.

I don't mean that these are the hydra's only heads, or that the heads couldn't be renumbered for other purposes. The critic Peter Plagens has suggested a schema with three parts, and for many writers the only important division is between academia and everything outside of it. The seven heads swerve and blur together, and sometimes it seems there are many more, or else just one conglomerate Babel. Yet often enough the combined practice of art criticism can be imagined as seven—or so—separate practices. At least it seems useful to me to picture it that way.

A note, before I begin, about the examples I have chosen to illustrate the seven kinds of criticism. Some of the people I mention here are friends and acquaintances. I hope that what I say about them is balanced—but it is very difficult to criticize criticism! It is rarely done, so art critics are not always used to the kind of pointed attack-and-parry that is common in literary criticism and in academic disputes. (Aside from the occasional irate letter, journalistic art criticism is normally insulated from debate.) At any rate, my primary interest is not the particular texts and writers I will mention, but the general problem of understanding how visual art is currently described.

*

1. The *catalog essay* has to be the least-read of the seven, even though the sum total of catalog essays may be comparable to the sum total of newspaper reviews. (Here I am talking about ordinary essays in exhibition brochures, not essays in books printed for major museums.) Catalog essays are not taken seriously because it is widely known that they are commissioned by the galleries. In practice this is a much more insidious and subtle procedure than it appears, because I find that people who write catalog essays do not normally imagine themselves to be constrained in any important way. They write what they please, and they are happy to find good qualities in the work. Critics I know do not feel pressure to write positive reviews or to avoid negative judgments, and I have been told that there is no censorship involved.

My own experience makes me doubt that optimism. I have written catalog essays for friends, and I have also accepted commissions from gallerists and curators. When I write for friends I don't want to say anything derogatory, and so the process goes very smoothly. I think of those essays as real criticism, which just happens to be mostly positive. Writing for artists I do not know personally, and for gallerists and curators, is a different matter. At first I was surprised by the matter-of-fact tone that the gallerists or their artists took when they wanted me to change something I had written, as if the essay were a dish in a restaurant that could be returned. I once ended an essay about an artist whose work I admire with the sentence fragment: "A lovely, overwrought, breath-

taking, intricate, mysterious, sad painter." (Not a very good sentence fragment, but that is another question.) The painter did not even bother to ask me whether I would consider cutting the word "sad": she simply took it out of the essay because, as she explained later, she isn't sad. But the essay had motivated that word by comparing her with an eighteenth-century artist, and I thought then, and still do, that "sad" is exactly appropriate and illuminating. In other cases I have gone back and forth with gallerists and artists, revising essays bit by bit so that they would sound more positive. From my point of view, a complicated and conflicted artist is more interesting than one who is simply fabulous, but catalog essays are read the way that employers read letters of recommendation: the slightest hint of something wrong, and the writer is taken to secretly abhor the person being recommended. In the case of larger exhibitions, essayists are given more freedom, but that does not prevent the artists from objecting, and a negative response from the artists may mean that the essayist will not be asked to write for the next exhibition. I wrote a long essay for an exhibition at the Essl Collection outside Vienna, called "Ungemalt/Un-painted;" the essay ran exactly as I wrote it, but several artists objected to what I had written about them. The objections were not invitations for further discussion: they were blanket dismissals. In one case the artist said only that I had gotten him wrong. That kind of response only makes sense in an art culture where successful artists are rarely exposed to critics or historians who ask to be taken seriously. Naturally, in that cloistered climate, artists assume they know their work better than anyone else.

Few people read catalog essays with concerted critical attention. A more typical reading experience, the kind catalog essays are meant to foster, involves glancing over the text, finding phrases and concepts that signal the work's importance. Catalog essays are generally best when they appear absolutely authoritative, studded with references to important names and works, and the best essays also exude enthusiasm about the artist's importance. The arguments should not be too complex, because they need to buoy a reader who may only be skimming the text. At the same time the arguments should not be wholly obvious because they may need to sustain a reader's faltering confidence in the work. If an essay is too simple, a reader may conclude there isn't much to the work after all: hence the need to be just a little extravagant. Tone matters, and so does a suspension of full argument in favor of open-ended evocation.

To illustrate some of this, I take an example nearly at random from my shelves (my groaning shelves, which hold something like three thousand exhibition catalogues): a catalog for an exhibition of paintings by Kate Shepherd (b. 1961) published when she was artist in residence at the Lannan Foundation in Santa Fe in 1999. As Kathleen Merrill, the director, puts it in her introduction, Shepherd's paintings depict "boxes, incomplete boxes, lines, or solitary points drawn over two monochromatic areas of color." The boxes and lines are very fine, perfectly ruled, and black. The monochrome color fields are perfect rectangles. The catalog essay was written by Rob Weiner, now Assistant Director at the Chinati Foundation in Marfa, Texas. He begins by noting how Shepherd's earlier work was figurative: she painted flags,

shoes, and flowers "with grace and delicacy," in a "subtly detached" and "poignant" manner. The new work is consistent because "it is composed with a limited visual vocabulary of distilled geometric forms," establishing "an empirical game where the rules keep changing," and eventually achieving "a delicate balance." These opening sentences produce three effects common to contemporary catalog essays: they evoke high-art ambitions by associating Shepherd's work with a major movement (minimalism), they emphasize the artist's seriousness (by pointing out her consistent purpose and trajectory), and they come to no particular conclusion except that the artist's work is balanced between conclusions. Later in the essay Weiner makes a far-flung association to strengthen the sense of Shepherd's relation to serious painting of the past: he compares her vertical paintings to "handsome, Spanish 17th Century full-body pictures that often occupy a neutral stage-like space: a good pedigree, poised and dignified." Throughout the essay he elaborates the ways in which her paintings are balanced, enigmatic, and ambiguous:

> In fact, a bend or blip may not be an accident at all but something deliberately left in to playfully subvert our expectations. And Shepherd's approach couldn't be more secure. The visual breaks call to mind an ellipsis—the omission of a word (here a mark) necessary for construction but understood in the larger context. Her hovering volumes are carefully composed of lines that might abruptly end in mid-thought. It is a fragile and beckoning geometry asking us to participate in its shaky conclusions.

It isn't easy to summarize the arguments in a text like this one, because there really aren't any. Weiner is trying to be sensitive to the painter's open-ended compositions, and his aim is to show how subtle they are, without coming to a definite conclusion. When essays like Weiner's work, they demonstrate a conviction in the artist's heritage: Shepherd is a post-minimalist by implication, and Weiner says she belongs in a line that descends from seventeenth-century portraiture. The limitations of the genre are also apparent: almost nothing is said about the hundreds or thousands of other post-minimalist painters who work in a similar style, or about the current possibilities of geometric abstraction, or about the scholarship on the subject, or even about earlier responses to Shepherd's work. Terms like "ellipsis" are not really worked out, and there is no sustained analysis of an individual image. It would be interesting, for example, to know exactly where an ellipsis takes place on one of Shepherd's paintings, and precisely how its effect differs from that of an ellipsis in a written text. In Weiner's essay, Shepherd's work floats in a serene and nearly empty space, without the burden of history or judgment.

All this pertains to average catalogue essays, written for the tens of thousands of commercial galleries worldwide. It can be a different matter when the essays are commissioned by major museums and galleries to accompany thematic shows and retrospectives. Those essays, packaged in outsize exhibition catalogues, can be indistinguishable from art historical monographs. That kind of writing raises interesting questions of its own, especially because it can be so conservative that it risks going unread not only by the museum visitors who

purchase the catalogues (it is known in the publishing industry that large museum catalogs are bought as coffee-table ornaments), but even by the community of art historians. Happily those are not problems that concern me here. What matters for the current state of art criticism is the truly enormous number of relatively brief, average-quality essays that is produced each year, and the fact that they are not read or even preserved in libraries.

2. The *academic treatise* is academic in tone, not necessarily in affiliation. One of the better writers in this vein is Caoimhín Mac Giolla Léith, a professor of Celtic Studies at University College, Dublin. He is an authority on the Irish language and one of its sister Celtic languages, Scots Gaelic. (Caoimhín is the Irish for "Kevin.") He writes art criticism as an engrossing but unofficial avocation. It is wholly typical of universities worldwide that Mac Giolla Léith is unaffiliated with the university's Department of Art History and that his work as an art critic is done on his own time. (The most prominent example of institutional exile is Simon Schama, who works in the History Department at Columbia University rather than the Department of Art History and Archaeology.) The faculty in Art History do not generally know the artists Mac Giolla Léith knows personally, nor do they know where he is traveling in any given semester, or what art he is writing about. In the last decade of the twentieth century Mac Giolla Léith built an international reputation as a critic, and made connections not only with artists, but also with art historians. I call his writing "academic" on account of the range of allusions and references he brings to bear. It is not easy to characterize the mixture of linguistics, French post-structuralism, Marxism,

phenomenology, semiotics, and psychoanalysis that comprises such work, but the names and terms are familiar ones in the contemporary art world. Jakobson, Benveniste, Deleuze, Guattari, Benjamin, Merleau-Ponty, Saussure, and Lacan are common, and among the frequently-used technical terms there is the punctum, the objet petit a, the screen, the gaze, the pharmakon, the parergon, the Other, the dialogic imagination, the supplément, différance, ousia, the trait, and the rhizome. There are many more such terms, and by themselves there is nothing objectionable about them. Every academic field has its specialized terms. Mac Giolla Léith does not use these words as jargon—that is, as deliberately opaque concepts meant to increase the text's authority—but he does use them as place-holders for argument. By that I mean the concepts and writers' names function in his text the way that Biblical references can work in a sermon, increasing the weight and persuasiveness of the whole without driving the individual arguments. Mac Giolla Léith's essays usually make use of several theorists and terms, and sometimes he moves very rapidly from one to the next; the result is a kaleidoscope of methods, concepts, and sources that accumulates into a critical mass, suggesting a larger argument but not necessarily building to it step by step. Reading his work, it can feel as if the density of the critical discourse is as important as the points that are made enroute to that density.

Part of the kaleidoscope-effect comes from the fact that Mac Giolla Léith came to art criticism from outside the art world, so that his earlier writing sometimes had solecisms and awkwardnesses of reference. But in a deeper sense—one in which his work is exem-

plary and not at all deficient—Mac Giolla Léith is heir to postmodernist practices in which rational argument is itself open to question. The art historian Rosalind Krauss has often risked a collaged succession of interpretive methods in order to achieve what she considers an appropriate theoretical density. When the approach works, it makes the art that much more difficult to discuss: it raises the level of discourse and puts an end to easier approaches. When it fails, the approach seems to be more a matter of finding erudite connections, and playing with the poetry of unexpected allusions, than of illuminating the artwork. I put it this way because academic art criticism is not necessarily Leftist or obscurantist. There are good reasons to doubt the straight-ahead logic of some earlier critical practices, but there are also compelling reasons to be wary of tapestries woven of recondite allusions. They may seem brilliant at the time, but their bright colors fade.

There is wide latitude among the writers I am calling academic. The English critic Michael Newman, for example, comes to art criticism from his training in philosophy. He has written a book on Emmanuel Levinas, and his writing reflects a number of issues at stake in post-structuralist thinking from Heidegger to Derrida and Jean-Luc Nancy. Other critics, especially those who were trained as artists, manage only tenuous references to post-structuralist philosophy. A crucial point in assessing such writing is the degree of detachment from primary sources. There is an entire sub-genre of art writing that refers so loosely to philosophic ideas that it effectively creates a new discourse, independent of the primary philosophic texts. References to concepts such as the objet petit a

(originally Lacan's concept) and the parergon (originally Derrida's, and before him, Kant's) are effectively newly minted in such writing. I do not think this is necessarily a fault. Concepts that had fairly continuous traditions of usage in their original settings are rediscovered in the art criticism, where they appear in the matrix of the writing like rough emeralds or diamonds found at random in unremarkable soil. It seems to me that is one of the best arguments in favor of apparently inaccurate philosophic and critical references. Why not try to build a new kind of writing for a new subject matter? The worst argument, on the other hand, is that a skein of evanescent allusions is a sufficient response to the work: often academic allusions just stand in the way, clotting the prose with unjustifiable opacities. And that, in turn, opens academic treatises to journalistic sniping.

3. By *cultural criticism* I mean the avalanche of magazine and newspaper criticism that includes art, but does not present itself as art criticism. Writers of this kind prefer to sound off-the-cuff, clever and hip, disabused and jaded, ironic and distanced. An example is Sarah Vowell, who writes all kinds of cultural criticism; her agent's website bills her as an author and "social observer" and says "she has written about everything from her father's homemade cannon and her obsession with the Godfather films to the New Hampshire primary and her Cherokee ancestors' forced march on the Trail of Tears." When she was a student in the school where I teach, Vowell was magisterially uninterested in the histories of criticism or art. The fun that she has with the cultural mix is characteristic of a line of pop-culture critics that goes back to Lawrence Alloway and continues in work by a very

diverse group of writers including Nicholas Mirzoeff, Dave Hickey, and Victor Burgin. A common thread is the assumption that fine art has become thoroughly entangled in popular culture, and from that observation it sometimes follows—although not in Alloway's case—that it is old-fashioned or misguided to engage in special pleading for "high" art. In Vowell's writing one effect of the cultural mix is a knowing end-of-the-line position, which implies that all sorts of things are unwittingly funny and deserve a laugh. Nearly any earnest and unaware cultural practice—which is to say, practically all of culture—must be seen ironically as kitsch or camp. (It is appropriate that Vowell has made guest appearances on *Late Night with Conan O'Brien* and *The Late Show with David Letterman*.) Naturally, from that perspective, there is no particular point in being an art critic: art criticism is disbanded and dispersed into wider cultural criticism. Its seriousness, in particular, is apt to be regarded as a silly lapse.

Here is one example from the tsunami of popular cultural criticism, written by an artist named Janis Demkiw. It appeared in *Lola* magazine and was reprinted in the *Toronto Star* on January 20, 2001, under the headline "Urgent, Honest, Witty Art Criticism":

Henry Moore sculpture at the corner of Dundas and McCaul Sts., 4:30 a.m., Sept. 30. The scene: Post-post Vaseline, post Sherry Boyle's after party, walking home on Dundas St. W., passing the AGO [Art Gallery of Ontario], we notice a black puddle running down from the platform of the Moore sculpture. It looks like motor oil… we're thinking vandalism. Further along, bits of car are showered across the sidewalk—glass, a side

mirror, a hub cap. Examining the sculpture, we find streaks of white car paint etched onto one flank. Some f*** had jumped the curb and slammed right into the Moore and Her Majesty was not even dented. One of those lovely surreal moments…finding something spectacular while the city's shut down, and knowing that the evidence would be cleared up in a matter of hours. (Incidentally, we found out later that the AGO got footage of the whole thing on their security camera. Now THAT is f****** Art.) The Verdict: Moore can withstand the test of time, and well… pretty much anything. Feel somewhat sorry for the car, though.

Notice that this is nothing if not ironic. (I am playing on Robert Hughes' title, *Nothing If Not Critical*: by comparison with this, Hughes is a stern dinosaur.) The first word of Demkiw's title, "Urgent," proclaims the irony, and so does the play-pretend conclusion that the Moore sculpture "can withstand the test of time." It sounds as if Demkiw doesn't care about that kind of art, and that is the fun. Yet there *is* an aesthetics in this anti-aesthetic: the word "surreal" signals it. Cultural criticism often depends on the pleasure that comes from unexpected juxtapositions of high art and popular culture: Moore and car crashes. The writing is conflicted: if high and low, fine art and popular culture, were in fact wholly blended as some cultural criticism implies, then juxtaposing disparate parts would no longer produce a *frisson* of campy pleasure. Cultural criticism still needs to have a little laugh at the expense of the defenders of art, and that is evidence that high and low are still separable—and that, in turn, means that cultural criticism can ultimately be an evasion of some serious issues in contemporary culture.

A small percentage of current cultural criticism, including some of Vowell's writing, really is uninterested in the difference between high and low. The test is that the writer takes no particular pleasure in poking at the few surviving bits of high art. I find that kind of democratic "iconophilia," as Bruno Latour calls it, tremendously rare: it doesn't happen in university courses in cultural studies, which retain an interest in contemporary fine art; it doesn't happen in magazine or newspaper criticism, where fine art is still carefully distinguished from popular images; it doesn't happen on TV, where high culture is seen as pompous and silly (as in *Frasier*); and it doesn't happen in Hollywood, where films from *Batman* to *Die Another Day* take random snipes at art (in *Die Another Day*, Gainsborough's *Blue Boy* is slashed, and in *Batman*, the Joker signs a Francis Bacon painting in mock-admiration).

In addition to *Lola*, Demkiw also contributes to the e-zine "Saturday Edition," put out by the website Instant Coffee. Alternate venues like those are among the first to go all out, and have fun with contemporary culture in its entirety, without the little laugh at high and low. In most cultural criticism, fine art is like those stubborn floury lumps in a powdered soup mix: they just won't dissolve, but it's OK anyway because they taste good.

4. It is irresistible to take Hilton Kramer as my example of the *conservative harangue*. In 2001, an unsigned editorial for Kramer's journal *The New Criterion* proposed that:

> From the beginning, what we have tried to offer is not simply coverage but criticism. By "criticism" we mean

"discrimination," that is, informed judgments of value.... It is also worth noting that discrimination is not the same thing as hostility—though it is in the nature of things that a discriminating assessment of the contemporary art world will also be, in large part, a negative assessment. How could it fail to be? For what we are talking about is a world in which chicanery, ideological grandstanding, and cynical commercialism are rampant. It says a lot about our times that, in many circles, to mention this is to be guilty of dubious taste.

Criticism here is a matter of "discriminating between better and worse, success and failure." The writer is presumably Kramer, and the editorial certainly reflects his views: in Kramer's eyes, the lack of discrimination and the failure of contemporary art go together. The writer here wants skillfully made, unpolitical art, done in the name of "harmony and tradition." Those values have sometimes led Kramer straight out of the artworld. He wrote an interesting review of the painter Odd Nerdrum, who might seem at first glance to be an ideal painter by his criteria: Nerdrum is tremendously skillful, scornful of commercialism, and engaged with moral issues—even though it is difficult to say exactly what they are. Kramer begins by noting that Nerdrum has not had any success with the "official art world." Nerdrum's work repudiates "virtually all the reigning orthodoxies of contemporary art": he is "unapologetic" about his return to Rembrandt, he is consummately skilled, and the moral outrage of his subject matter makes him "as 'modern' as *Guernica*." Nerdrum's paintings are "proudly anti-modernist, and yet they owe little, if anything, to the posturing of the post-modernist camp." By those criteria, Kramer should enlist

Nerdrum as a major painter—yet he can't quite bring himself to say so, perhaps because he senses just how strangely lost in time Nerdrum really is. Life at the Kramer Hilton—it is Gore Vidal's phrase, and it is irresistible—is insulated from the rude shocks and lowland fogs of the actual art world.

5. The *philosopher's essay* is perhaps best exemplified at the turn of the new century by Arthur Danto, though a denser and more concertedly philosophic tone has been adopted by Thomas Crow in writings on minimalism and conceptual art. For Crow those movements engaged preeminently philosophic problems and called for a philosophic criticism. They came "to provide the most important venue where demanding philosophical issues could be aired before a substantial lay public." Because of the withdrawal of philosophy into narrow academic circles, the conceptual artist, Crow says, "might legitimately claim the role of last public philosopher"— with the caveat that the claim to philosophic significance can "of course...be extended to very few." Crow's is a relentlessly demanding discourse, though he concedes that "it may seem a paradox to discern a way toward the rebuilding of consensual public discussion in language that, for the moment, excludes so many." For the time being, the best criticism has to be "distinguished by a thoroughly appropriate elevation of tone and an impersonal precision of language," because what matters is *exactly* what Sherrie Levine's plywood panels say about the reception of Western painting, or *precisely* what Gordon Matta-Clark's actions signify in relation to the minimalist dilemma of the relation between support and object. The works are not reduced to philosophy, because

at their best they *are* philosophy: they are problems and positions, enacted as visual art, and that makes them even more challenging and attractive to a serious critic than conventional philosophic problems posed in words. (My own difficulty with some of Crow's more philosophic-minded essays is that the problems ostensibly embodied by the works are really not that interesting or "demanding" *as* philosophy. But the intersection between claims that works have irreplaceable philosophic importance, and their appearances in the text, is not my subject here.)

Danto writes with a lighter tone, but he also cares about philosophic cogency and the capacity of certain artworks to serve as examples of logical and philosophic problems. His philosophic essays—as opposed to his art criticism, which I will get to in a moment—tend to circle around his well-known claim that the history of art ended with Warhol's *Brillo Boxes* in 1963. In my experience, two kinds of readers are especially interested in Danto's philosophic writing and in the thesis regarding the end of art history. One group is comprised of philosophers, sociologists, and educators; and the other is mainly artists who use the end-of-history claim to release themselves from the obligation to weigh their works against those of other artists. For that second kind of reader, Danto is a liberatory force, relieving the last obligations to history, and giving artists a license to stop considering their place in the history of modernism and postmodernism.

At the same time as he pursues his theory about the end of art history, Danto continues to write art criticism for a variety of museums and galleries in America and in Europe. The art criticism raises wholly different

issues. What interests me most is the very idea of writing art criticism after the end of the history of art. If there has in fact been "a shift from hermeneutic practices (which are 'about' something) to a new pluralist play where no discrete content is involved," as the philosopher Martin Donougho puts it, then art criticism could be expected to be something quite new. Danto's position, as I understand it, is that he writes criticism from his own point of view, and that any other might be as valid. In the state of art after history, anyone's voice might be helpful, and there is no longer any sense in promoting one interpretation over another.

It is a very strange position, given that Danto's criticism abounds in historical references and judgments, even when he is writing about artists who worked after Warhol. Movements, styles, artists, and ideas are compared with one another, often quite persuasively, exactly as they had been before the end of art history. Danto has not theorized the different force of the new, allegedly non-art-historical art criticism, and it seems to me that it *cannot* be theorized: after all, what account could hold that a judgment about abstraction, for example, means one thing when it is applied to Pollock and another when it is applied—in the same terms, in the same institutional contexts, using the same values—to contemporary abstraction? In logical terms, the only way to divorce contemporary art criticism from criticism before the *Brillo Boxes* would be to write without using judgments and concepts that were in use before 1963. That would be possible—I could write an essay about abstraction using terms borrowed from electrical engineering or physics—but it would not count as art criticism for many readers. In

any case, Danto makes no such attempt: he just writes art criticism, in the same voice he adopted before his first text on the end of art history in 1984. He asks only that readers no longer take his art criticism as having historical force or interpretive power above or below any other critic's efforts—but how can that be anything other than wishful thinking? Strictly speaking, I think Danto's art criticism is *illegible* because it is not possible to read it as he requests, as if he were just playing out a pluralist game, offering one opinion in a cacophony of incommensurable voices.

Let me belabor this a moment, because Danto's positionless position is important for contemporary pluralism. He claims, in effect, that art-critical references to practices before 1963 can work without implying they are *about* historical references: but the only way such references can be understood *as* references (and what else would they be?) is by being about historical works and meanings. They are empty without historical anchors, because there is no way to read them. Nor can art criticism after 1963 just be a matter of chronicling artists' choices, because those chronicles could have no meaning for people who hold that such choices are no longer histori-cally significant—no meaning, that is, unless they imply that the artists are misguided. And why say *that*?

Some of the most interesting art criticism in recent decades can be called philosophic in the sense I am using the term here. Crow's claims on behalf of concep-tual and minimal art, Stephen Melville's very thoughtful, deconstructive readings of the art of the 1980s, and Whitney Davis' exemplary recent work on sculpture, are all examples. I am allowing myself to group them here only because in the larger field of art criticism, they share

the common trait of taking artworks as irreplaceable sites for philosophic work.

6. *Descriptive art criticism* is another twentieth-century development, and it is the hydra's second-biggest head. Art writing that attempts *not* to judge, and yet presents itself as criticism, is one of the fascinating paradoxes of the second half of the twentieth century. The Columbia University survey of the top 230 American art critics—those who work for the largest-circulation newspapers, weeklies, and national news magazines—found that the critics think the most important aspect of criticism is "providing an *accurate, descriptive* account": the goal I call descriptive art criticism. One respondent says art criticism is a matter of "forming a 'bridge' or opening a 'dialogue' between artists and readers;" another is interested in "motivating readers to see and buy art;" a third wants to introduce readers "to different cultures and alternative viewpoints." A fourth respondent (they are all anonymous in the survey) says simply: "we are paid to inform the reader of what's in town." Dialogues, evocations, motivations, introductions, bridges: they are all synonyms for good description. Unfortunately, there is no international survey of art critics to complement the Columbia University survey. The charter of the International Association of Art Critics, which is the closest to a representative of art critics worldwide, says nothing about descriptive criticism. It proposes, on the contrary, that AICA is interested in finding "sound methodological and ethical bases" for art criticism. That has not happened, perhaps because the majority of art critics is not primarily concerned about methods or ethics.

After description, the second most-emphasized goal of art criticism in the Columbia University survey is "providing *historical and other background information*": an ideal I would identify as art history. "A piece of art criticism should place a work in a larger context," as one respondent puts it. That purpose is entirely unobjectionable, because historical context is unavoidably part of assessment. It is *necessary* for art criticism, but strictly speaking, it cannot be *sufficient* because then art criticism would simply be art history. I agree with Kuspit's observation that part of the critic's task is to find the work's bearing in history, to win it "a hearing in the court of history." But that can't be what art criticism is, as opposed to art history.

Some descriptive criticism does present itself as art history, or as material for some future art history. Several critics who saw early versions of this text wrote to tell me description was their principal goal. One told me, "we talk to each other to get what is happening now on the historical record," so there is something from which to work. Michael Kimmelman, chief art critic for *The New York Times*, has said that his *Portraits: Talking with Artists at the Met, the Modern, the Louvre and Elsewhere* (1998) might function as primary source material for a future art historical account of the artists he interviews. That is likely because several of the interviews in the book record unique encounters between artists and works they had chosen in the Metropolitan Museum of Art and elsewhere. Yet the book is not merely meant as source material, because Kimmelman also jousts a little with art history in his introduction: "artists here restore to past art, I think, a sense of immediacy that

historians seem to fear or neglect… Rembrandt is a great figure but we don't have to like his work." Art history is described as a discipline that avoids judgment and succumbs to an unrealistic sense of the past. For Kimmelman, "artists are like critics in the old Bloomsbury sense": they "treat Old Masters with the same urgency or disdain that they feel toward new art." That is often true, but there is plenty of contemporary art history that begins with issues of quality and relevance, and takes its partisanship seriously *as* history. If this were a pamphlet of historiography, I could trace the history of art historians' awareness of urgency, disdain, fear, and neglect. That history could easily grow to include entire national traditions of art history that would turn out to be just as invested in the judgment of history as the critics and artists in Kimmelman's book.

It is a matter of contention whether or not it makes sense to divide critics and artists from art historians in the way Kimmelman proposes. But it is certainly true that art historians tend not to pay much attention to artists' own personal favorites. Kimmelman notes that the artists he interviewed tended to praise some of the same works, among them Pollock's *Autumn Rhythm*, Philip Guston's *Street*, and sculptures by Giacometti. Other names that crop up repeatedly in Kimmelman's book are Lucian Freud and Balthus, along with a dozen or so premodern artists. Even though there has not been much art historical work on artists' personal canons, the choices artists make are not as capricious or idiosyncratic as they may seem. The surprise and challenge that Pollock poses have become immured in viewer's responses since the 1960s, and the artists Kimmelman interviews are not original in

voicing those sentiments. Guston's legacy has also developed into well-worn paths of response: his figuration has become a touchstone for those who want to legitimate their distance from anti-figural rhetoric, although the sheer sadness of his work still provokes denial as much as fascination. (In Kimmelman's book, Susan Rothenberg says she finds the garbage-can lids in *Street* "cute," and compares them to "halos." I imagine Guston would have thought that reaction was horrific.) Few artists in Kimmelman's book mention Picasso, and that is also historically explicable. Art historical databases show that for the past twenty-odd years Picasso has been the subject of more monographs and essays than any other artist, modern or premodern, but artists still find his legacy problematic and even irrelevant: a relation that depends, as several art historians have noted, on a kind of willful repression that the art historians themselves apparently do not feel. In accord with his non-judgmental purpose, Kimmelman lets the artists choose the works they want to discuss, and he does not press them to provide reasons. It does not follow that there are no reasons, and they can be sought in various accounts of twentieth century art.

Kimmelman hopes his book will stand apart from art history and also from more judgmentally driven criticism. He wants it to occupy a space aside from polemics, where the artists' own ways of talking can create a new kind of conversation. The problem with that is not only that art history is invested and "urgent," and not only that art historical research can, in fact, fill in the gap between what the artists say and what other people have written about modern art: the difficulty is that if no such bridges are built, Kimmelman's book will be effectively meaning-

less. Listening to artists muse about artworks they find intriguing may appear to create a new path toward their work, but it can only have meaning when it has some-thing—a prior sense of history, a prior scholarship—to contrast itself against. Kimmelman's choices are varied, but they are all internationally known: Balthus, Elizabeth Murray, Francis Bacon, Roy Lichtenstein, Lucian Freud, Susan Rothenberg, and a dozen others. Many other choices would have been possible, and chance led Kimmelman to several of his interviews; but by and large his choices do form a group because they are artists who have been supported by the market, which is in turn connected to the entire apparatus of criticism and art history. I do not mean that Kimmelman's choices are market-driven: I mean that the artists *appear* meaningful as well as significant precisely because of the apparatus of art history that Kimmelman says is alien and irrelevant to his project. Art history and criticism have provided the *reasons* why these and other artists seem important, and it may be wishful thinking at best, or incoherent at worst, to proceed as if a non-intrusive interview format can elicit a conversation that is disconnected from that prior history, or at least sufficiently distant from it so that what the artists say need not be connected to that prior history in order to make sense.

That is half the problem I find with Kimmelman's book, and with descriptive criticism in general. The other half is the idea that it might be possible to build a larger and less provisional account by proceeding in the same fashion, interviewing more artists, until something approaching an independent discourse can be achieved. *Portraits* is a modest book, and it does not make claims

beyond its sixteen interviews. But it implies that if more people were willing to be attentive to artists' own choices and ways of talking, then it would be possible to create a way of thinking about visual art that is both true and sufficient. I do not think that will ever be possible, because the various opinions that the artists voice in *Portraits* can only have meaning against a backdrop of previous opinions, judgments, research, writing, and promotion that constitutes the sum total of the history of twentieth-century art. It is no more possible to proceed along the road of *Portraits* than it would be to write a history of seventeenth-century French art by just noting—without further explanation—that Poussin said Caravaggio wanted to destroy painting. Such an account would have to make do without a consideration of Caravaggio's reception, the alternatives open to Poussin, the place of the Carracci, or the debates between the Ancients and the Moderns. By itself Poussin's judgment is unexpected, apparently idiosyncratic, and therefore entertaining. But as Louis Marin's work shows so eloquently, Poussin's meaning can be elucidated by following what was written and taught in the seventeenth century: that is, by studying contemporaneous art history and criticism. A more ambitious version of Kimmelman's book would include historical and critical evaluations of the artists' statements; it would be read as art criticism or art history or both, but not as a third term. Descriptive art criticism is like raw ore that has just been mined. It is not the useful objects that we want to make from it.

Kimmelman's *Portraits* may be the first book of descriptive criticism by a newspaper critic who is ordinarily interested in judgment. The more common kind of

descriptive art criticism is the newspaper or magazine review where strong judgments are avoided as a matter of course. My friend and colleague James Yood, who has been Chicago correspondent for *Artforum* for many years, has a long-standing interest in not judging art in print: he sees his reviews as an opportunity to let viewers get a sense of new art without ruining their experiences by prejudging the work. He measures his adjectives very carefully, to create a balanced assessment that is neither too positive nor too negative. Writing about the painter John Pittman—the paintings in the exhibition were loose grids of thin lines, not unlike Kate Shepherd's—Yood says the "sense of accretive evolution and deliberate tempo prevented the paintings from seeming too rigorous or severe." That is a well-balanced sentence: it raises the possibility that the work is severe or overly rigorous, but tempers it by noting the work is also built according to a less formal, "accretive evolution." Notice how finely tuned this is: the expression "deliberate tempo" says the same thing in miniature, balancing "deliberate"—which can sound lugubrious, as in "deliberation"—with "tempo"—which sounds upbeat. And as if that were not subtle enough, the next sentence qualifies the description still more: "Instead, their subtle dynamism gave them a casual and inevitable profile, one that is clearly the residue of highly intelligent design." That is the last line of the review, and it leaves the work in a nearly perfect balance, tipping just at the end into praise that is at once quite generous and carefully hedged: the work is "very intelligent," but its intelligence is really just a "residue."

These are judgments, of course, all of them. I don't dispute the notion—itself a modernist idea—that

description is judgment. "Precision of language is the best kind of judgment," as Peter Schjledahl says. A finely tuned judgment can probably only be made in finely chosen words: otherwise the subtlety is clobbered by abstractions. I do not doubt that description is judgment, but I think it is important not to confuse the intention to judge subtly with the intention not to judge. The latter masquerades as the former, and the former nourishes the latter. Contemporary art criticism is entranced by the possibility of avoiding judgment, and critics who equate description and judgment sometimes deceive themselves about their own interest in avoiding judgment.

Yood's sense of balance, and Kimmelman's interest in providing primary source material, seem entirely reasonable to me, but I think there is a yawning gulf between what they do and what has historically been practiced as art criticism. Descriptive criticism begs the question of what criticism is by making it appear that there is no question. As I imagine it, the argument must run like this: the fact that it is possible to avoid what Kimmelman calls Bloomsbury criticism (that is, personally invested and strongly judgmental writing), implies there is a promising area for writing about art that is cleansed of intemperate judgment. The fact that it is also possible to avoid the desiccated neutrality of some art history implies that art criticism can occupy a ground apart from the pressures of historical precedents. I do not think so: the new non-judgmental writing can be pleasant, but too often the pleasure comes from having escaped from the burden of historical judgment.

It is not easy to characterize descriptive criticism, as these two examples show. Some of it is motivated by an

intellectual suspicion of art history, and some is more a matter of not tipping the scales for people who haven't experienced the art firsthand. Given its mixed motivations, it stands to reason descriptive criticism has several origins. As far as I can tell it comes from at least seven sources. (This list of seven has nothing to do with the hydra heads: it just happened that when I collected sources for descriptive criticism I ended with seven.)

(a) An explanation I do not wholly credit has been proposed by Jeremy Gilbert-Rolfe, who said at a conference in 2001 that the increasingly high rents on galleries have forced gallerists to make safer choices, which in turn have forced art critics to acquiesce in order to be published. That is certainly part of the problem, but it pertains more to Manhattan than to smaller cities, and it works better as an explanation for catalog essays (my first hydra head). It still needs to be said why so many critics, from so many places, *prefer* to describe rather than judge.

(b) Another way of explaining descriptive criticism is to note that in the 1980s there was widespread awareness of the sheer power of the art market. Some critics took that as a cue that art criticism was—in the language of the time—epiphenomenal on the market. Serious art criticism seemed superfluous, and it looked as if critics were not essential for the dissemination of art. This explanation is certainly part of the story, but it also fails to explain the fact that the plurality of critics *choose* to write descriptive criticism. There is relatively little grousing about the power of the market—which has, in any case, collapsed since 1990.

(c) Descriptive criticism has been said to spring from an awareness that art styles proliferated after Pop,

making rigid judgments inappropriate. Descriptive criticism of this kind has long had an apologist in Thomas McEvilley, who proposes that postmodern criticism should be an exegetical practice rather than a polemic one. Its purpose is to be local, attentive to the specifics of the work, and evocative.

(d) Hal Foster has argued that one of the projects of the generation of art critics who started writing in the mid-1970s, in the wake of Greenberg and the first generation of *Artforum* critics, was "to work against" the identification of judgment with art criticism. Conceptual art, minimalism, and institutional critique all functioned to make art criticism inessential. In a roundtable on the state of art criticism, held in fall 2001 and published in the journal *October*, Benjamin Buchloh says that in conceptual art, "the meddling of the critic was historically defied and denounced." The *October* exchange, which otherwise gives evidence of the isolation of *October* in relation to the wider practices of art criticism, is illuminating on this point: descriptive criticism can be said to derive from a central move in the art of the 1970s against what had been taken to be differences between critical thought and artworks.

(e) In 1971, Rosalind Krauss proposed that in the wake of modernism, art criticism should be considered primarily a forum for the examination rather than the exhibition of judgment. In 1985, in the Introduction to the collection *The Originality of the Avant-Garde and Other Modernist Myths*, she said that criticism should expose "those choices that precede and predetermine any act of judgment." Greenberg's modernism had presupposed art's unity with judgment itself, so that "the point of criticism

[had] everything to do with value and almost nothing to do with method." In this account, reflection on judgment is a way of opening a space between postmodern concerns and Greenberg's high modernism. Yet even if "modernist art appears to have come to closure," so that judgment itself can now become an object of reflection, and even if criticism has "opened...overtly, onto method," it does not follow that critical practice should be wholly or even mainly about the interrogation of judgments. In fact, Krauss' text puts art criticism in a very odd position: in a literal reading, she is calling for a criticism focused entirely on the elucidation of the conditions of other people's judgments. Most descriptive criticism has less pure motives.

(f) Some descriptive criticism springs from the art historical interest in telling the history of things without getting involved. The 1990s saw a resurgence of interest in *Rezeptionsgeschichten*, reception histories, in which the object of study is the ideas people once held about art. In their pure form, reception histories take no stand for or against the quality, importance, or even truth of their subject. The historian of nineteenth-century art Marc Gotlieb has written a reception history of the idea that artists had studio secrets that they passed on from one generation to the next. (The most famous example is Jan Van Eyck's supposed secret formula for oil painting.) Gotlieb is not concerned about the existence of actual secrets, but on the effect that the idea of secrets had on the ways people thought about art and artists. Other reception histories have been written about Van Gogh (tracing how he became famous after his death) and Paul Klee (chronicling his gallerist's efforts to create an image for him, and

to propel his career). Reception history becomes extremely interesting when it is used to study art or ideas that are still being contested, because it presents them as pure products of past thinking. It does not matter to most living artists whether Van Eyck had specific formula for oil paint, but it matters a great deal whether Clement Greenberg's ideas still have force—if they can be thought of as true for some kinds of painting, or even for modernism in general. (The ongoing reaction *against* Greenberg shows that at least some of his ideas still compel conviction.) Caroline Jones' forthcoming study of Clement Greenberg will probably be the most important modern *Rezeptionsgeschichte* because Jones is interested in the conditions under which concepts such as "purity," "avant-garde," "flatness," and "abstraction" were taken seriously enough to launch the career of a critic like Greenberg. The simple fact that Jones takes no stand on the value or even the coherence of concepts like "abstraction" and "truth" may come as a shock to the majority of artists in the world who are either still coming to terms with Greenberg or who have not yet encountered his works in the original. (In my experience, the latter group includes the majority of working painters in South America, Asia, and Africa.) What could Jones' study possibly mean to people who are just now becoming aware of Greenberg's ideas?

(g) Another source of descriptive criticism is institutional critique. This is a kind of art criticism that has been practiced since the 1970s, and can be associated in particular with the art critic Benjamin Buchloh. In the *October* roundtable that included Buchloh, the artist Andrea Fraser exemplified institutional criticism when

she said that "divisions of labor within the art world are fundamentally divisions of the labor of legitimation. The latter are fundamental to the production of belief"—note that phrase, "production of belief," which keeps her at a distance from actual belief—"in the value of the work of art by providing an appearance of autonomous invest-ments or autonomous judgments that appear, to varying degrees, as sublimated with respect to the material dimen-sions of that value and to the personal and profession[al] stakes that participants in the field have in the production of that art." This is formidably eloquent, and formidably coherent in its position that value is a construction, an illu-sion, or a belief produced by the conditions of labor. From this perspective there is little sense in producing yet more judgments: what matters is being aware of other people's values, and the means by which they have come to be thought of as truths.

Judgment is paralyzed in institutional critique, pinned by two assumptions that attack it, as it were, from both sides. On the one hand it is said that judgments accompany and enable whatever can sensibly be said, so that it is unnecessary to become clear about what those judgments might be, and perhaps even pernicious because trying would imply that judgments can be teased apart from the matrix of thought that enacts them. If I make a remark about an artwork, I have judged it, inadvertently and instantly, and there is no benefit in prying the form from the content. On the other hand it is assumed that judgments are a leftover of a previous condition of culture: they are avatars of modernism, or worse, they're fossils from the centuries before modernism. Judgments that parade themselves as such are taken to be inherently

conservative and ill-fitted to contemporary art. It is tremendously important to realize that these two claims have nothing to offer against the possibility that an awareness of the historical bases of judgments might go hand in hand with ongoing, committed, ambitious judgments.

Hence non-judgmental criticism, in my pocket genealogy, has at least seven roots. These are fragments, I realize, and I know they do not comprise a good answer to the question in my title. It may be that the subject itself is not prone to any single explanation, or that we are still too close to it. What matters most is that we keep the sea change in view: the ebb of judgment was one of the most significant changes in the art world in the previous century.

Several of the seven explanations have to do with the market, and so it is worth saying that pure economic market reporting, as it is found in magazines such as *Art Review* and *The Wall Street Journal*, also counts as descriptive criticism when it purports to assess art rather than just report on prices. Pernilla Holmes' "Report Card" for Jules Olitski does the usual number-crunching one finds in economists' reports. After Salander O'Reilly started buying up the works in 1990, Holmes says, "canvases from the Sixties and Seventies, estimated anywhere between £60,000-£120,000, suddenly fetched well over £200,000." The essay is not entirely economics, however. Holmes also finds it "significant" that the "guru of art criticism at the time, Clement Greenberg, referred to Olitski as our greatest living painter." Here art criticism becomes an element in the market, stripped of its contexts and arguments and reduced, in classical Marxist fashion, to the exchange values it may have helped create. I don't

know Pernilla Holmes, but I assume she is not a cynical capitalist, because she also writes reviews of twentieth-century painting that have nothing to do with sales figures. But at least in this report, art criticism is treated with the same ruthless neutrality as a market analyst treats the contribution Christmas cheer makes to the Dow Jones average.

Another way to look at descriptive criticism is to say it has just two hydra heads, or to mix mythological metaphors, to think of it as a Janus-faced hydra head. One side is benign, aiming only to enhance a reader's sense of the art. Jed Perl, art critic for the *New Republic*, writes in what the orator Demetrius called the Plain Style: straight-forward, clear, descriptive, and consistently attentive to the work. As Demetrius said of the Plain Style, the purpose is mainly to engage the reader without recourse to ambiguity, technical language, or hyperbole. The other side of descriptive criticism is passively destructive, because such writing must always dilute the drive to judgment, isolating art criticism from both judgment and art history, and rendering it diplomatic and innocuous.

7. *Poetic art criticism* is my final hydra head, and it is the most prominent of all. The Columbia University survey of art critics found that the third most-popular purpose of criticism was "creating a piece of writing with *literary value*." Describing artworks, providing historical context, and writing well were the top three answers on the survey. The bottom two were "*theorizing* about the meaning, associations, and implications of the works being reviewed," and "rendering a personal *judgment or opinion* about the works being reviewed." Only 39 percent of the critics rated theorizing as a priority, and

only 27 percent rated judgments and opinions as priorities. I was amazed to read that, because theorizing and judging were principal goals of art criticism from Diderot to Greenberg. It was less surprising that the third-most popular answer was "creating a piece of writing with *literary value*." In the absence of methodological and theoretical interests, and for those less dedicated to descriptive work, writing—and sometimes just "entertaining"—is a high priority.

I call this category poetic art criticism to underscore the fact that some prominent critics are also poets, Peter Schjeldahl and Michael Fried among them. Poetic art criticism has a noble lineage; it also includes Baudelaire and Wilde, both of whom said that ideal art criticism was poetry or—in Baudelaire's conceit—"sonnet or elegy." When it is not literally the case that the critic is a poet, then poetry is an emblem of the desire to create writing that is interesting in and for itself. It goes without saying that this is an admirable goal; I have said it myself, and it has been said by critics as different as Herbert Muschamp, Carter Ratcliff (also a poet), Oscar Wilde, and David Carrier. In a talk in 2002, Michael Kimmelman called it his principal aim. But does it have to be said that writing well can't be an adequate goal for art criticism? Don DeLillo told an interviewer that his main interest is in constructing perfect sentences, and yet somehow he ends up writing about the Kennedys, Mao, and the CIA. Similar claims about the priority of good writing have been made by a number of writers from Vladimir Nabokov to William Gass. Even Harold Rosenblum said "the essence of art criticism" is "the ability to write well." He also said it was "an imagination

cultivated in metaphor," which goes to show that good writing is a signpost to practically everywhere. I will not stray into the muddle of woolly notions about the relation between good writing and good content. Perhaps art criticism has become so hopelessly trackless that something as old as writerly ambition appears to be the best criterion. At least it's anodyne and faultless.

At the end of the twentieth century, the two most visible critics who made a special theme of writing were Peter Schjeldahl and Dave Hickey. It is instructive to see the drubbing Hickey gets in the *October* roundtable. He is associated with critics whose writing, "having pretensions to the literary, is valorized for its tone of sensibility and its capacity to seduce." James Meyer says Hickey comes from the tradition of anti-academic poet-critics that includes Frank O'Hara and James Schuyler. Hal Foster says Hickey has developed a "sort of pop-libertarian aesthetic, a neo-liberal aesthetic very attuned to the market." Robert Storr is the only panelist who defends Hickey, saying his public is really just "people who like to read and think about art," but Buchloh is surprised that he has influence among artists, and calls him a "rhapsodic substitute" for serious art criticism. Helen Molesworth says Hickey doesn't actually function "as a critic of art per se," which is fair enough because he rarely writes about specific pieces of contemporary art. The panelists note that Schjeldahl shares many of Hickey's perspectives, which is not a compliment to either, and George Baker proposes that "Schjeldahl is often involved in baiting the anti-intellectualism of the public." All in all, Hickey comes across as an unimportant practitioner of something resembling "belletristic" writing: it is not art criticism, but

at least it is honest about the market. I wonder if the many artists and art critics who take pleasure in Hickey's work would recognize him in this collective portrait.

More than any other critic, Hickey makes readers think about voice, tone, and style, and that may account for some of the wild opinions about his work. He also infuriates academics by refusing to write at any length about particular works of contemporary art, and by steering clear of the kind of argument that could be distilled into a *Cliff's Notes*. For his part he avoids anything that has the taint and pretension of academia, and for that reason he is extravagantly attracted to non sequiturs, repetitions, asides, apostrophes, jokes, self-contradictions, impressionistic collages, delightful but largely pointless reminiscences, rough unpolished passages that sit cheek by jowl with prose poems, and especially to wild leaps of all sorts—between the distant past and breaking news, syrupy nostalgia and hard-baked cynicism, success and failure, West and East, high and low, refined and pornographic. It is as if writing itself had swallowed critical decorum, proper argument, and academic protocol, chewed them well, and spat them all out in a big spill of prose.

Hickey is not alone in preferring prose that refuses to be dressed up as logical argument. Among contemporary critics, the French writer Jean-Louis Schefer can be substantially less comprehensible, and so can Ticio Escobar, the Paraguayan critic—although neither of them shares Hickey's severe allergic reaction to academia. (Why, I always wonder, avoid academia so religiously? Why not mix it all together, as Schefer does?) Comparisons aside, Hickey is easily the best example of a

contemporary American critic for whom form is as important as content.

The goal of writing well is unobjectionable, and I hold it in mind as I write this sentence: but it just can't have anything to do with the goals of art criticism. It can't be a definition, or an ideal, or even a quality. It is too labile, and too flimsily linked to critical content, to be relevant to the project of trying to understand what art criticism has become. The quality of writing is only relevant when it is used as an excuse not to think about the other purposes of art criticism. That, I think, is the reason why "literary value" is the third-most popular goal of art criticism according to the Columbia University survey: critics who say writing is their primary goal are necessarily avoiding the more difficult question of what *else* art criticism might be.

*

Those are my seven hydra heads. There could be many more. If I were building a long list, the next item would be artists' statements and manifestos, which have functioned as art criticism from Boccioni to Robert Morris. Or I might be tempted to add large parts of art history, especially those historians who were caught up in advocacy (Aby Warburg, Max Dvorak, Max Friedlaender) or who sometimes swooned with aesthetic delight (Bernard Berenson, Roberto Longhi, Frederick Hartt). But seven heads is enough for one beast.

3

Seven Unworkable Cures

It is tempting to try to escape the fog of current art criticism and run out into the clear air of certainty. Of course, everyone has their own idea about where that clear air might be found. The people on the *October* roundtable want more attention to rigor, theoretical sophistication, and "levels of complexity in discourse." Others would prefer it if art critics had rules, norms, theories, or at least some concerns in common. There have been laments that the twenty-first century has no guiding voice—even one that might help us through the decaying labyrinth of pluralism. Newspaper calls for the reform of art criticism usually attack jargon, and promote simple ideas. Conservative commentators want to boost art's moral purpose. Kramer wants to bring in a bit of old-fashioned discipline, "discrimination," and firm standards. Newspaper critics themselves sometimes want to reform criticism by removing its connection to the market.

I think things are more difficult. The very idea of finding something wrong with the current state of criticism is itself historically determined. Why should *October* have a roundtable discussion on criticism, a kind of writing it has largely refrained from publishing, in the fall of 2001? Why does a text with the title *What Happened to Art Criticism?* appear in autumn 2003? It is important to understand why a problem comes to the surface at a given point in time, because we all ride currents of historical thinking of which we're only intermittently aware. Thinking about the reasons for various calls for the reform of criticism helps reveal that the proposed solutions tend to be born from nostalgia for specific moments in the past. Let me try to demonstrate that with seven examples of increasing length and difficulty. (These do not correspond to the seven hydra heads: but once you start thinking in sevens it is hard to stop.)

1. *Criticism should be reformed by returning it to a golden age of apolitical formalist rigor.*
In *A Roger Fry Reader*, the art historian Christopher Reed proposes Fry can be interpreted as a "postmodern" critic on account of his complexity, his "iconoclastic relation to authority," and his "social mission." Hilton Kramer wrote his usual impatient review, claiming Reed's perspective is unworkable and false: a typical product, Kramer thinks, of postmodern "historical nullification." In place of Reed's version, Kramer wants a thoughtful but conservative Fry, one who was never an "avant-garde incendiary." Kramer's dislike of politically-inflected art criticism prompts him to stress Fry's interest in finding laws of art in "a realm apart from life"—a phrase Reed uses to

remind readers that is not *all* that Fry did. There's nothing to stop Fry from being reborn for each new generation: that is the nature of historical reception. Yet Kramer's Fry is Kramer *avant la lettre*: a brilliant formalist, who knows and respects the older history of art, and is unafraid of proposing "a realm apart from life." Clearly, Kramer's polemic is driven by nostalgia. He wants things the way he imagines they once were, and that is not a plausible model for contemporary criticism.

2. *Criticism lacks a strong voice.*

In 1973 the artist and art historian Quentin Bell lamented the decline of authoritative art critics using the same observation with which I began: "while the literature of art is, in publishers' terms, booming, it has in one respect suffered a loss." What Bell misses is a critic who can be a "censor" and "apologist for the contemporary scene, a Diderot, a Baudelaire, a Ruskin or a Roger Fry." Why is there no such "grand pundit" on the art scene? Perhaps, Bell thinks, it is the "character of modern art," which is difficult to discuss, or maybe it's the spread of high-quality illustrations, which obviate the need for description. Unfortunately for Bell's argument the history of criticism shows that many, perhaps most, decades since Vasari have lacked a strong critical voice. Criticism was weak and dispersed before Winckelmann, as Thomas DaCosta Kaufmann has shown. It was weak after Diderot, as Michael Fried has argued. After Baudelaire there were many interesting critics, among them Theophile Thoré, Ernest Chesneau, Jules Castagnary, Edmond Duranty, Félix Fénéon or Albert Aurier, but none have been as important for modernism as Baudelaire. Criticism was

arguably weak again before Bloomsbury, and again before Greenberg. It doesn't reflect poorly on us that we have no prophet at the moment. Bell's complaint is another instance of a nostalgia for something past: in this case, mainly a Bloomsbury past.

3. *Criticism needs systematic concepts and rules.*

To some observers criticism just seems like a mess. In the 1940s the aesthetician Helmut Hungerford wanted to arrange paintings in "classes," and to work out standards such as organization, integration, and skill, that are relevant for each class. Behind his dogged rationalism I read an anxiety about the fate of formal analysis. Hungerford's criteria crumbled around him, even while he tried to shore them up by proposing additional criteria of "coherence" within classes and standards. These days, as far as I can see, he is entirely forgotten. Perhaps art criticism cannot be reformed in a logical sense because it was never well-formed in the first place. Art criticism has long been a mongrel among academic pursuits, borrowing whatever it needed from other fields (the sublime and the beautiful, of judgment and imitation, of the gaze and the spectacle). It has never been a matter of the consistent application of philosophic concepts, and there is little sense in hoping that it ever will be.

4. *Criticism must become more theoretical.*

Perhaps, then—lowering the bar a bit here—art criticism might make use of shared theoretical interests, no matter where they're cribbed from. The film critic Annette Michelson argues that in a brilliant essay on Pauline Kael. She compares Kael to Umberto Eco (who wrote an essay

on *Casablanca*): the "very obvious difference," Michelson says, is that Eco is convinced that "the infusion and support of an evolving body of theoretical effort will work to the advantage of communication." Michelson thinks that Kael's "intransigent resistance to the theorization of the subject of her life's work inhibited her ability to account for film's impact in terms other than taste and distaste." As the years went on, Kael "ceased to renew her intellectual capital, to acknowledge and profit by the achievements of a huge collective effort." This is an admirable way of putting the point: it is crucial to be part of the same reservoir of concepts and theoretical tools as the rest of the generation, even if they only enter into the work in the form of unused capital. I would find it difficult to argue against this: it is not dogmatic, and it isn't propped up by nostalgia for some earlier state of perfect passion and eloquence. I'll have more to say about it at the end.

5. *Criticism needs to be serious, complex, and rigorous.*
This call is more or less the consensus recommendation in the 2001 *October* roundtable, and it has a particular lineage: it can be traced to the critics associated with *Artforum* from its founding in 1962 to around 1967. Critics including Carter Ratcliff, Rosalind Krauss, John Coplans, Max Kozloff, Barbara Rose, Peter Plagens, Walter Darby Bannard, Phil Leider, Annette Michelson, and others were part of a loose and ultimately divisive group that nevertheless shared a sense of criticism's newly serious purpose. Amy Newman's book of interviews, *Challenging Art: Artforum 1962-1974* is a good source for the group's elusive sense of community. In *Challenging*

Art, John Coplans suggests that the wave of commitment to analytic criticism came indirectly from expatriate German scholars, preeminently Erwin Panofsky, despite the fact that several of the art critics began their careers by repudiating work by art historians such as Sydney Freedberg. Coplans points out that the only prior American model for serious criticism was *The Magazine of Art*, especially when Robert Goldwater became editor in 1947. *The Magazine of Art*, he says, was "absolutely against the French method," which was perceived as a tradition of poets. Several of the critics and historians Newman interviews make analogous claims: the poet and critic Carter Ratcliff recalls how some poet-critics remained interested in "a private history, a personal history," while others, the *Artforum* group especially, "tried to establish some *defensible* scheme, a schematic of history," into which they placed new art. "And in that way," he concludes, "they could keep track of history *right as it happened*." In the same book, Rosalind Krauss distinguishes between the *Artforum* kind of criticism and a preeminently French "*belle lettristic*" kind of writing, where "poets would compose emotive catalogue prefaces for artists." The criticism published in *Artforum* was indebted, she says, to Anglo-American New Criticism, which:

> involved a textual analysis in which the project was to make statements about the text in front of you that had to be verifiable. You couldn't introduce things about the artist's biography or about history. It was really limited to what was on the page so that any reader who was at all competent could *check* what you were saying about the work.

Aside from Greenberg, Krauss says, she had been "very frustrated by the vagueness and unverifiability of *opinion*" in English-language art critics such as Sidney Janis, Thomas Hess, Dore Ashton, and Harold Rosenberg. Nothing they wrote struck her as "*hard*, verifiable." Fried, similarly, mentions "all that fustian writing—Hess and the others." (*Fustian*, a very sharp-edged word for a woolly fabric, meaning not only bombastic and inflated, but also, as a consequence, worthless.) Coplans says the only criticism that seemed interesting in London in the early 1960s was "Lawrence Alloway fighting it out with Sir Herbert Read" over the importance of surrealism. Robert Rosenblum sums up the situation at *Artforum* by recalling an article by Max Kozloff called "Venetian Art and Florentine Criticism" (December 1967). "I loved the title," Rosenblum recalls, because "it put its finger on one of the problems of *Artforum* classic writing, namely it was Florentine, it was intellectual and bone-dry, and never really could correspond to the sensuous pleasures of looking at art." Rosenblum's special viewpoint aside (his writing is famously full-blooded, in these terms), the metaphor of Florence and Venice is accurate: *Artforum*, and later *October*, stood for rigor as against fustian writing of all sorts.

All that is the foundation of what "serious criticism" continues to mean. Since 1976, it has also been exemplified by *October*, and by essays written by Thomas Crow, Thomas McEvilley, and a score of others in different venues. Calls for a return to criticism that is serious, complex, and rigorous are indebted to the model provided by *Artforum* and its descendents. That means, in turn, that it is important to ask whether it makes sense to

revive those particular senses of commitment, verifiability, and intellectualism. It seems to me the only defensible answer is that such values are no longer a good fit for art at the beginning of the twenty-first century. Metaphors of intellectual *labor*, of difficulty, of challenge recur in *Artforum* discussions, beginning with Greenberg: when it is good the work is dry, hard, obdurate and irrefragable... it is not easy to imagine how those values can be transposed to the present, and even if they were, it is not easy to picture how useful they would be.

6. *Criticism should become a reflection on judgments, not the parading of judgments.*
This is essentially what Rosalind Krauss argued in 1971 and again in 1985, and it is put into practice in reception histories and institutional critiques, mainly in academic writing. If you conceive of the art world as a matrix of institutional and power relations, then there is no immediate sense to words like "quality" or "value": they are determined by divisions of labor within the art world, and produced for different purposes including academic power and market value. If you are interested in reception history, then the hard-fought battles in the art world become objects of historical interest. You will want to know the historical contexts that produced interest in words like "quality" or "value," and your interest will be purely historical or even philological—you won't have any more investment in the outcome than an entomologist has watching one army of ants battle against another. Even the explanation offered by institutional critique will become susceptible to reception history: the idea of institutional critique began in the 1980s, and has its own

historical trajectory. Within that course, its explanations for words like "quality" or "value" will have weight, but before, after, or outside it they will not.

The problem that faces both institutional critique and reception history is the present. We live in it, we make judgments in it. When we judge contemporary art, we engage concepts that we believe in—there is no other way to judge. For a person who practices reception history, that poses a truly difficult problem. Such a writer will be acutely aware that no concepts are born in the present. Concepts that are used to judge art must have their own histories, and once those histories become apparent, it will not be possible to believe in the concepts with the whole-hearted commitment that they once commanded. If a figure like Greenberg has already receded far enough into the past such that his discourse is an object of historical analysis, that means concepts at play in contemporary art are entirely unrelated to his. If they aren't—if Greenberg's senses of words like "flatness," "abstraction," "kitsch," and "avant-garde" are still echoing in the present—then the evaluation of contemporary art becomes extremely problematic. How, after all, is it possible to judge a work using criteria that are no longer believable, that belong to another time? When concepts all belong to past writers, criticism becomes chronicle, and judgment becomes meditation on past judgment. The present is immersed in history, and finally drowns in it.

These are difficult points, and I have put them as clearly as I can. As far as I can see, critics such as Buchloh who practice institutional critique and reception history do not take the confluence of everyday judgment and considered neutrality about judgment to be problematic:

like everyone, Buchloh judges new work as he encounters it, and he understands older works as the products of the conversations of their time. As a prescription for art criticism, the turn to reflection on judgment is still ill-resolved, especially when its aim is to replace art criticism.

7. *At least a critic should occasionally take a stand or have a position.*

This seems sensible, and even inevitable: it is a minimal demand. It is, however, exactly what is most in contention in contemporary criticism. Let me pose it as a contrast between two writers I take to be pretty much diametrically opposed. The first is Jerry Saltz, currently art critic at the *Village Voice*; the second Michael Fried, once the leading figure in *Artforum*. I know both of them, and I can hardly think of two more opposite people. Michael Fried, as everyone who has met him can testify, is absolutely and unswervingly faithful to certain theoretical commitments he developed in the 1960s: the project of modernism as he has delineated it; the indispensability of a fully informed sense of art history; the central critical and historical importance of art that compels, for a given time and audience, conviction. Jerry Saltz is a kind of inversion of those values: it's not that he isn't argumentative—he is as sharp and funny and talkative as they come—but in my experience at least his arguments are ad hoc, and he wants them that way. This is just as relevant to Saltz's art criticism as Fried's ferocious commitment is to his, because Saltz's writing is effervescent and colloquial, as if he were continuously surprised by himself. Saltz has a collection of forty thousand slides—the collection is so large that

MoMA has asked for it when he retires—and when he lectures, he shows pictures of all sorts of things: his taxi ride in from the airport, the look of the streets in the city he's in, and the outsides of the galleries he visits. It is not just a distraction, it's a warm-up for the swerving observations that will follow.

When I asked Saltz what essay of his best addresses the conundrum of the contemporary critic's position, he sent me to a piece called "Learning on the Job," which he wrote in the fall of 2002. In it he reports being buttonholed by Barbara Kruger, who reacted to his apparent lack of critical method by saying, "We really need to talk, buddy boy!" Part of the essay is Saltz's position statement, or rather lack-of-position statement. He is against theory, by which he means Procrustean formulas that shape experience before the fact. "My only position," he writes,

> is to let the reader in on my feelings; try to write in straightforward, jargon-free language; not oversimplify or dumb down my responses; aim to have an idea, a judgment, or a description in every sentence; not take too much for granted; explain how artists might be original or derivative and how they use techniques and materials; observe whether they're developing or standing still; provide context; and make judgments that hopefully amount to something more than just my opinion. To do this requires more than a position or a theory. It requires something else. This something else is what art, and criticism, are all about.

There are nine parts to that long sentence, separated by semicolons. The first, second, and third are

matters of tone and audience, and are not directly relevant at the moment. The fourth—to "aim to have an idea, a judgment, or a description in every sentence"—is a position against illogic, although it is also not a position in favor of a continuously developed logical argument. (I think it is actually impossible to write a grammatical sentence that doesn't express an idea, a judgment, or a description.) The fifth part, that he does not want to "take too much for granted," says again that he does not want to have a "theory" that guides experience. The sixth, seventh, and eighth clauses (beginning "explain how artists might be original or derivative" and including explaining to artists "how they might be original or derivative" and providing "context") are one hundred percent art history, not art criticism, and they contain a hint of a theory because they imply that innovation is better than repetition—that the avant-garde, or some multiplied pluralist form of it, remains an indispensable guide to criticism.

The ninth and final clause, promising to "make judgments that hopefully amount to something more than just my opinion," is to my mind the lynchpin of the paradox of positionless, or theoryless, art criticism. It is also the only clause of the nine that is about critical judgments, as opposed to art historical information, style, logic, or audience. It is likely, given human nature, that the judgments Saltz makes in *The Village Voice* will be shared by other people. Logically speaking, if everything he said were shared by only a few of his readers, his criticism would be extremely unpopular, and if everything he said were shared by none of his readers, it would be perceived as nonsense. But the clause "make judgments

that hopefully amount to something more than just my opinion" means more than that, because what is at stake is not popularity or sense, it is historical connection. Saltz's judgments amount to more than just his own opinion, and they do so by sharing common ground with judgments that can be assigned to streams of modernist and post-modernist thinking. This is where the paradox enters, because in my reading Saltz is saying both "I do not want to be fettered by theory," and "My criticism needs to connect to previous theories." He needs to connect, but not know too much about that connection: not to worry about it, not to get too serious or systematic about it. To keep the edge, stay nimble, and be able to make acute judgments, it is necessary not to think about other people's theories, but when the job is done—in the ninth clause—it is also important that the common ground is evident for those who choose to look.

It is not common practice to read newspaper criticism quite as slowly as I have here, or to read quite as much into it as I have. I don't doubt I have gotten this wrong from Saltz's viewpoint, but I also know this is what the sentence says. And just to be clear: Saltz's positionless position has granted him any number of wonderful insights. Consistency is the hobgoblin of little minds, he might say, and for the purposes of his writing and his encounters with objects consistency certainly has limited appeal—in fact it tends to appear as "theory." I do not object to any of that: spontaneity may be a fiction, and pure openness to an object may be impossible, but that is wholly irrelevant when it comes to the effects those putative states actually have on Saltz's writing. The difficulty begins when the sum total of his criticism is weighed

against other people's criticism—not that Saltz has ever said he thought such a project would be worth anything. But from my point of view, historical meaning cannot be kept back: once it begins to leak into a text, as it does in several of the nine clauses, the text will soon be soaked. Once a single judgment is made whose sense depends, no matter how obliquely, on judgments made in the previous history of art, then sooner or later every judgment will want to take its significance from history. And that means, according to the logic of floods, that no wall can keep historical meaning at bay: in the end it is not only possible but necessary to ask how the sum total of Saltz's writing compares with other critics' writing. This is the crucial point that is so often missing from arguments in favor of pluralism: if individual judgments, the building blocks of the text, are significant on account of their connection to art history, then the entire corpus has to be weighed in an historical balance. Not every day, luckily, and not while you are encountering the art or arguing with Barbara Kruger—but eventually, if *anything* is to make sense.

This same point is made with characteristic concision in Greenberg's "Complaints of an Art Critic," just after he has proclaimed that aesthetic judgments are "given and contained in the immediate experience of art," and wholly "involuntary." Even so, he writes, "qualitative principles or norms are there somewhere, in subliminal operation," because "otherwise aesthetic judgments would be purely subjective, and that they are not is shown by the fact that the verdicts of those who care most about art and pay it the most attention converge over the course of time to form a consensus." Greenberg did not suppose that the uncovering of such a consensus was any of his

business, and I do not think it is part of the brief of every piece of art criticism: but it becomes necessary whenever the question pertains to the sense and significance of a critic's *entire* position, or sum of positions. That is where Saltz's ninth clause becomes evasive. To "make judgments that hopefully amount to something more than just my opinion": they will inevitably amount to something more than his opinion, so the question is why only hope? Why not be the one who watches and keeps count?

What is *not* opposed to this in Fried's art criticism? The strength of his beliefs, and the way they are tempered with reasoned explanations, are especially clear in an exchange that took place at Brandeis University in 1966, during a panel discussion on criticism that also included Barbara Rose, Max Kozloff, and Sidney Tillim. Rose recalled that Greenberg once quoted Matthew Arnold to the effect that the task of the critic was to define the mainstream. But, she said, "at any given moment the mainstream is only part of the total activity, and in our time it may even be the least part. Thus to concentrate on the mainstream is to narrow one's range to the point where even tributaries to the mainstream, such as Dada, Surrealism, and Pop art, are not worthy of consideration." Fried replied:

> I feel tempted to say, if someone likes *that* stuff—putting aside the question of what, in a given instance, that stuff *is*—I simply can't believe his claim that he is *also* moved or convinced or flattened by the work of Noland, say, or Olitski or Caro. I mean that. It's not that I *refuse* to believe it, I really *can't*. I have no way of understanding what I am asked to believe. The most I can do is assume that whoever makes this claim

admires Noland's or Olitski's paintings or Caro's sculptures, not for the wrong *reasons* exactly, but, as it were, in the grip of the wrong experience—an experience of mistaken identity.

This is different but analogous to Greenberg's claim that he did not always agree with his own judgments, but that he was forced to make them. Fried implies he is in the grip of a position that is both reasoned—as the cogently imagined reconstruction of an opposing position testifies—and also passionate to the point of being irrevocable. Greenberg's most forceful articulation of his position on his own powerlessness in the face of his own judgment was made in the same essay "Complaints of an Art Critic," which was a contribution to an *Artforum* series of essays on the state of criticism. The most compressed statement of his position against the idea that a critic should have a position is this:

> You cannot legitimately want or hope for anything from art except quality. And you cannot lay down conditions for quality. However and wherever it turns up, you have to accept it. You have your prejudices, your leanings and inclinations, but you are under the obligation to recognize them as that and keep them from interfering.

Both Fried's and Greenberg's positions on the matter of conviction are outlandishly strong, and I do not know any critic or historian who has taken them as seriously as they want to be taken. Some art historians, including Thierry De Duve, have thought about what they imply, but that is as it were from the outside, as historical

observers of other people's theories. No one, I think, has taken them to heart, by which I mean considered the possibility or the desirability of having such convictions, entirely apart from the kinds of art that Greenberg or Fried championed. (As Fried said, "putting aside the question of what, in a given instance, that stuff *is*.") The usual attitude is to conflate Fried's or Greenberg's positions on conviction with the art they defended, making it possible to discard the former on account of the latter. That misunderstanding is what allows people to write off Fried after they have decided they don't like Olitski as much as he does, or to stop reading Greenberg once they've discovered he did not like Pop art. Things are more difficult than that.

Fried's *position* in the early essays is a matter of allegiance to modernist painting and sculpture, but it is not a position that can be *taken* in the sense in which a person says, "He took that position." It is a position that Fried held then and still does hold, but not one he chose out of a selection of other positions. If it were that kind of position, readers would be able to read his texts in such a way as to disclose the prior position that enabled him to "take up" the modernist, anti-literalist position. It would be possible to follow the antecedent positions, be persuaded by them, and take them up. The Greenberg of "Complaints of a Critic" would say that Fried's position is not a position that he needs to have *agreed with*: it is simply one he "accepted," because it compelled conviction and therefore drove the writing forward.

Saltz's *theory*—his theory abut how art critics should not have theories—is more akin to the kind of position that a person can *choose to take*, because Saltz

thinks of theory as a thing that springs from some irrelevant prior experience. If you decide your Theory of Everything over coffee before you go to the gallery opening, your review is apt to be atrocious. That kind of theory, or position, ruins the possibility of open-minded encounters with objects. In the course of his essays, Saltz does take up less permanent positions, but they are short-lived, sensitive to the changing art, the time of day, and his mood at the moment. Those kinds of unstable positions are probably better called *stances*. The word is common in contemporary art criticism, because it helps suggest that full-blown positions are too unwieldy in the current pluralist climate. *Stance* also suggests something that Fried and Greenberg would find wholly unacceptable: that the critic is an agent who stands back from the writing, picking and choosing positions to suit different occasions. That is the rhetorical force of the phrase, "My stance on that is..." as opposed to "My stand on that is..." The question that "stance" begs is the source of the authority that invests the critic-as-agent with the ability to pick and choose stances. What stand, what position, could permit and orchestrate the lightning-fast changes of stances that comprise contemporary art criticism? Saltz is like a weather vane, spinning around to match the breeze at any given moment, and Fried is like a thermostat, either on or off, with no intermediate setting. Between the two there is a curious and unexplored territory. Clearly, if art criticism is to be reformed by requiring critics to take definite positions, they cannot be the kinds of positions Fried exemplifies because those can't be taken: and if criticism is to go on without positions, it cannot go the way Saltz goes without running into the problem of not having positions.

Perhaps it is best not to worry the problem of positions at all, but to reform criticism by making it more honest, immediate, and engaging. Saltz writes energetically on all sorts of things without worrying about how he's doing in the absence of "theories," and Fried's pronouncements on criticism are rare in comparison to the essays that propose judgments about art. Still, positions can never entirely disappear. Robert Hughes is a curious example. He has weighed in on virtually the whole of Western painting after the Renaissance—his writing is significantly more comprehensive than all but just a few art historians—and in all that writing he has almost never pondered his positions. In a brilliant essay on Francesco Clemente, he sighs over the "elusive," "curiously polymorphous" art, which "always looks hasty," and is "usually banal." He quips: when Clemente "is light, he is very, very light." And he complains: most of the time, Clemente "draws like a duffer." Then he settles in to look at just one image, an enigmatic beach scene with five red wheels. Could they be from a child's cart? An allusion to Ezekiel's wheels of fire? Symbols for the rank of angels called Thrones?

> By the simplest means, one is shifted sideways into a parallel world of improbabilities. At its best… Clemente's work lives a tremulous, only partly decipherable life at the juncture of eros and cultural memory. It is rarefied, intelligent and decadent, although its intelligence is more literary than plastic and its decadence never fails to make collectors want to cuddle it.

This is wonderful writing: judicious, measured, improvisational. The final "cuddle" is a typical hit:

Hughes made much of his reputation by deflating reputations. Reading Hughes, I have often had the feeling that if he were to say what he was looking for, or what he found himself responding to—if, in other words, he would present observations as if they were theories—then I wouldn't be interested. He has said he values clarity, poise, technical skill, solidity (de Kooning's early drawings are "all nuance and doubt on top" and "iron below"), senses of space, a redeeming "cultural synthesis" (Pollock), an "unmistakable grandeur of symbolic vision" (Kiefer), concreteness over abstract ideas, and art with "its own scale and density" as opposed to mass media. These ideals are insubstantial and tend to evaporate in the face of the works. They are also, as he would acknowledge, mainly late romantic and early modernist concepts. (Most can be found in Cortissoz's criticism at the turn of the century.) Hughes is broadly popular in America and England, but in my experience he is not regarded with any special interest in academia. Aside from all the usual reasons including academic élitism, the neglect is caused by the lightness of the ideas that serve as his positive criteria. Readers like him, I think, because they like his impatience with sham, and they enjoy the rawness of the reasons he gives. Those attractions may keep their minds off the uninteresting reasons why art succeeds.

It really does matter that Hughes can write great salt-and-pepper prose, and that he comes out with brilliant images, like the one of Greenberg's disciples "rocking and muttering over the last grain of pigment" in Morris Louis' canvases, "like students of the Talmud disputing a text, before issuing their communiqués about the Inevitable Course of Art History to the readers of *Artforum*"—or, my

own favorite, the notion that Max Beckmann is poised "between the sleep walk and the goose step." But when the subject comes around to twentieth-century art criticism as a whole, in its relation to art history and to wider intellectual debates, then it does matter when debunking takes precedence over thinking about the shape of history, and it matters that Hughes' positions, insofar as they can be gleaned between the lines, are not put to the test by comparing them with previous judgments. Hughes doesn't care much about what other people have written, so he focuses on debunking received ideas and on finding the right words for his own responses.

Positionless art critics, including those like Hughes who are just not interested in positions, can still be compelling. Yet there is a difference between a critic such as David Sylvester, who was scrupulous about his own reactions even though he often had no idea how they might fit in with other people's, and a critic like David Banks, who recently praised installation art by the Bristol artists Sonya Hanney and Adam Dade by admitting that "in the grand tradition of art criticism, I don't know a lot about it, but I know what I like." Often what Sylvester has to say springs directly from his own visceral reactions: "art affects one in different parts of one's body," he told the critic Martin Gayford in an interview in 2001. "For example, sometimes in the solar plexus or the pit of one's stomach, sometimes in the shoulder blades…or one may get a feeling of levitation—an experience I particularly associate with Matisse." Sylvester's narrow focus is justified because phenomenology frames his critical approach; Banks' opinions can't be defended in the same way, and neither can Hughes'.

There is a lot of treacherous ground between the kind of unwanted convictions that possessed Greenberg, and the positionless position—the theory of theorylessness—espoused by Saltz. In between are the intense convictions, both possessed and possessing, that drive Fried's art criticism, and the fugitive criteria that sometimes appear in Hughes' writing, and then vanish just as quickly. Art critics who do not seem to have positions can end up having them anyway, when the sum total of many judgments seem to point in one direction, the way a swarm of gnats slowly rises or falls even though the individuals are moving in all different directions. A position can materialize out of the most concerted efforts to avoid being consistent. All that is par for the course: it's the way writing works. Positionlessness finds its limit, however, when the writing itself implies there should be a position. A critic who recoils from theories may fall prey to an autoimmune reaction when his own criticism implies that he does in fact have a position. On the other hand, a ferociously strong position or Theory of Everything limits discourse with other critics and historians, and in Greenberg's case it even seems to have limited his articulation of the genesis of his own preferences. Clearly, it is dubious at best to reform art criticism by requiring art critics to have positions: it leads back along an uneven path toward a kind of commitment so ferocious even the person who held it, Greenberg, described it as a force outside himself. It's not that the opposite is best—it's that positions are not things to which a person can return.

This ends my list of seven proposals for reforming criticism. My moral is simple: no reform comes without the very severe penalties of anachronism and historical naiveté.

4

ENVOI: WHAT'S GOOD

So I do not think it is necessarily a good idea to reform criticism: what counts is trying to *understand* the flight from judgment, and the attraction of description. Yet my skepticism about other people's complaints and prescriptions does not prevent me from saying what kinds of criticism I admire.

When I read newspaper art criticism, I am usually on the lookout for openly offered opinions. I want to know what the critic thinks—and I enjoy sensing the irritation or passion behind what is said—and I like to get a sense of what the critic might argue about larger historical movements such as cubism, surrealism, modernism, and postmodernism. I get annoyed if I think that the critic is using the pluralism of the contemporary art scene as a license not to think about larger issues, or if I suspect the critic is hiding a lack of reflection behind a façade of brilliant

writing. Through most of the 1990s my scapegoat for these faults was Peter Schjeldahl: I found him entirely exasperating in his persistent unwillingness to make clear judgments or to collate his thoughts from one column to the next, and I was often disappointed by what I took to be his insouciance about all judgment—a carelessness I thought he justified, between the lines, as the best part of postmodernism.

At the end of the millennium, Schjeldahl began to frame his judgments less ambiguously, and to address larger historical questions. An essay called "Surrealism Revisited," published in February 2002, is as close to ideal contemporary art criticism as any I know. The occasion was an exhibition at the Metropolitan Museum of Art called "Surrealism: Desire Unbound." The essay reviews the show, and has entertaining things to say about several works, but Schjeldahl also has bigger business in mind. Toward the end he starts worrying about surrealism's punch. "My own trouble with Surrealism, which becomes acute at the Met, centers on that word 'desire.'" Surrealism was "without doubt sexy," and it showed "a mighty yen for serious, collective purpose," but can "desire" keep it alive for twenty-first century audiences? No, because "a little earthy skepticism can make short work of 'Desire Unbound.'" Partly that is because surrealist painting can be just plain weak: Ernst is "hectic and pedestrian," Dalí "groans with dated conceits," and no surrealist approached de Chirico—although "an exception might be made for the arch philosophical jokes of Magritte, but not by me." Partly what bothers Schjeldahl is the very notion of desire: how dangerous is it, anyway? "All this heavy breathing," he writes, "suggests feelings

so classy that I am impressed right out of feeling them." He ends by comparing surrealist painting unfavorably with Pollock's *Pasiphaë*, which was hung in a gallery at the end of the exhibition. "Every stabbing brushstroke and surprising color breathes lyrical urgency. The canvas blazes with cumulative energy." Pollock chose Jungian analysis over Freudian, Schjeldahl notes, which "helped disperse Surrealism's erotomania and narcissism. Desire was no longer an issue—only conviction mattered." In the end, surrealism was less a forum for what painting could be than a "labyrinth of intellectualized sex."

To my mind it is a brilliant essay. It effectively comes to terms with one of the most debated modernist movements, and it does that in just 1,600 extremely care-fully chosen words. Schjeldahl's rejection of surrealism is different from Greenberg's, and his objections are not aimed directly at the art historians who privilege surre-alism such as Rosalind Krauss and Hal Foster. Schjeldahl's account is just independent enough to count as a new sense of surrealism. T.J. Clark and others have objected to the supposed power of surrealist transgres-sions, and at one point Schjeldahl comes close to Robert Hughes' sense of Abstract Expressionism as an American expression of space. "Surrealism Revisited" conjures something that can be conjured with: it does not get in the way of his opinions about works outside of surrealism, and it does not take him away from the business of being entertaining and unpredictable. It puts a welcome pressure on his own future work, and on other critics' writings about surrealism, because it registers a definite position with measurable consequences. Within the limits of jour-nalism's word counts the essay has more insights per para-

graph than most books on surrealism: it exemplifies some of what I find best in contemporary writing. It shows that the short formats and general readership of newspaper art criticism need not be barriers to historically reflective and judiciously opinionated art criticism.

*

I could have ended a few pages back, with the list of reasons to be skeptical about reforming art criticism. But that would have played criticism false in the name of art history. An historian can afford to step back, and ponder other people's motives for change. Critics also have to be ready to respond with their own opinions. So here, to close, are three qualities that most engage me in contemporary criticism. They are open to the same objections I raised about other people's proposals: they have their histories, and they can be interpreted as evidence I want to return to some unnamed past—but so be it! That's the nature of criticism.

1. *Ambitious judgment.*
Art criticism is best, I think, when it is openly ambitious, meaning that the critic is interested in comparing the work at hand with past work, and weighing her judgments against those made by previous writers. I like art critics who periodically try to bear the burden of history by writing in the imaginary presence of generations of artworks, art critics, and art historians. I am engaged by critics who show signs that they have read the literature, when it exists, and who have thought out the main claims about modern and postmodern art made by writers from

Adorno and Benjamin to Lyotard and Jameson. Much of current newspaper and magazine criticism is written from viewpoints that could be easily explained—and fatally critiqued—by reference to the major theorists of modernism. Yet it is not an impossible demand to ask that newspaper critics respond to primary sources and to the history of their discipline. The most interesting critics show that it is possible to acknowledge complex ideas and practices even given the short formats, broad public, and tight deadlines of newspaper publishing.

2. *Reflection about judgment itself.*
Art criticism can content itself with description, but then it loses the run of itself, becomes something else, dissolves into the ocean of undifferentiated nonfiction writing on culture. Art criticism can be a parade of pronouncements or "discriminations," as the editorial in the *New Criterion* has it, but then it becomes conservative, or begins to smell of dogmatism. I find myself engaged by critics who are serious about judgment, by which I mean that they offer judgments, and—this is what matters most—they then pause to assess those judgments. Why did I write that? such a critic may ask, or: Who first thought of that? Art criticism is a forum for the concept and operation of judgment, not merely a place where judgments are asserted, and certainly not a place where they are evaded. At the same time, criticism cannot become *exclusively* a forum for meditation on judgment, as Krauss once said, because then it would lose itself in another way—it would dissolve into aesthetics, or into trackless meditation.

3. *Criticism important enough to count as history, and vice versa.*

Because it is journalism, I don't expect to see "Surrealism Revisited" mentioned in the next Yale or MIT Press book on surrealism. But it should be, and it should also be noted by other journalists. Build the conversation, as Annette Michelson says. I would love to see art criticism from *The New York Times*, the *New Yorker*, or *Time* be cited by art historians in journals like the *Art Bulletin*, *October*, or *Art History*. It could be, if its arguments were tight enough. I would like to see catalog essays from ordinary commercial galleries be cited in art historical monographs published by university presses. They could be, if they were written with attention to issues current in art history. Newspaper criticism is cited by historians after enough time has passed, but that is because it is valued as historical evidence, showing how works were received. What I mean is that contemporary critics who have cogent readings of artworks could enter into the conversation of art history. And of course this is a two-way street. It would also be good to see art historians' names and ideas showing up in newspaper art criticism. Why not have the conversation going in both directions?

In order for that to happen, all that is required is that everyone read everything. Each writer, no matter what their place and purpose, should have an endless bibliography, and know every pertinent issue and claim. We should all read until our eyes are bleary, and we should read both ambitiously—making sure we've come to terms with Greenberg, or Adorno—and also indiscriminately—finding work that might ordinarily escape us. Some art critics avoid academia because they think it's

stuffy and irrelevant, but that is just silly. (There is no other word.) And it is just as silly for art historians to spurn contemporary art criticism. The hydra may have seven heads, or seventeen thousand: but it is speaking with all of them, and each one needs to be heard if we are to take the measure of modern art. ■

Acknowledgments

Who would have thought it would be so hard to write about art criticism? For many conflicting comments I thank Elaine O'Brien, David O'Brien (no relation), Rachael DeLue, David Raskin, Michael Newman, Jonathan Fineberg, Michael Kimmelman, Peter Fitzgerald, Arthur Danto, Jerry Saltz, Peter Schjeldahl, Mary Sherman, Caoimhín Mac Giolla Léith, Leah Ollman, Michael Fried, Martin Donougho, Margaret Hawkins, Jerry Cullum, András Szánto, and Jeremy Simon; and I especially thank Peter Plagens, who wrote me several long, energetic, and deeply dissatisfied letters. This revision will not placate him.

This text is part of a work in progress called *Success and Failure in Twentieth-Century Painting*. Please send comments and complaints to the author via www.jameselkins.com.

Look for these titles by Prickly Paradigm, and others to come: